UNVENTIONS

EVERY INVENTION HAS AN EQUAL AND OPPOSITE UNVENTION

UNVENTIONS WILL CHAN

YOUR WORLD FOREVER*

*LARGELY IN UTTERLY USELESS WAYS

ISBN 978-1-908211-03-3

A catalogue record for this book is available from the British Library.

First published in Great Britain in 2011 by Carpet Bombing Culture
Cameron House, 42 Swinburne Road, Darlington, Co Durham DL3 7TD
email: books@carpetbombingculture.co.uk

© Carpet Bombing Culture

Cléon Daniel 2011
The right of Cléon Daniel to be identified as the author of this work has been asserted by him in accordance with the Copyright, Designs and Patents Act 1988.

Carpet Bombing Culture
since 2008*

www.carpetbombingculture.co.uk
*We make books. You buy them. Your life is better.

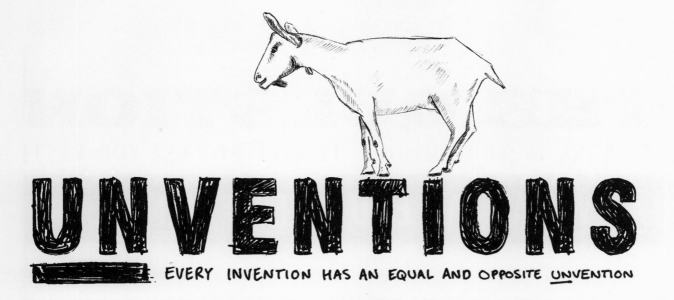

UNVENTIONS

EVERY INVENTION HAS AN EQUAL AND OPPOSITE UNVENTION

THE QUESTION
IT BURNS IN YOUR MIND... IT WILL NOT LET YOU REST!

WHAT ARE UNVENTIONS?

LEARN THE GREATEST SECRET DISCOVERY
OF THE LATE 20TH CENTURY

It is believed at the time of writing that some two hundred and twenty two thousand unventions were logged at the UK patent office between 1976 and 2003. No one knows why they suddenly came into existence, nor why they ceased to be submitted so abruptly. They looked at first like ordinary inventions, blueprints and patent applications of the kind submitted daily by hopeful inventors even now. But they were not so. Their peculiar nature was too much for some, and for this reason they were hidden away in a secret office and there they accumulated.

CHANGE YOUR WORLD FOREVER

EVERY THING YOU SEE HERE IS ALREADY IN YOUR MIND...

A CHANCE DISCOVERY

In 1987 the patent office started to go digital. It was then, whilst having a tidy up that a young lad on work experience discovered something he shouldn't have... Sworn to secrecy and with the threat of a ruddy good kicking to keep him quiet, our lad kept his head down working in the full stop department for 6 months, but it was too late - higher, more liberal authorities intervened, and a full report of the findings published for the world to see..it's what you're holding in your hands right now...

SO, JUST WHAT ARE UNVENTIONS?

Some say unventions are simply everyday objects that are familiar to all.

They are correct. But they are also wrong.

Unventions tell new stories about the things around you.

Releasing them from the mundane trudge of daily routine to take on epic new roles.

When you begin to see them you are set free, and soon you will discover your own.

Your mind has been in chains for too long!

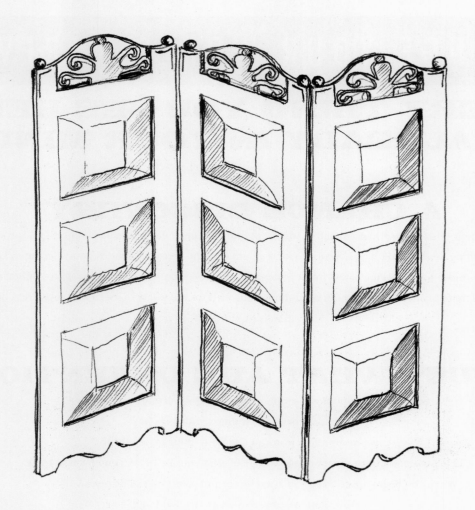

BULLSHIT DEFLECTOR
To block out any close by bullshit, place this around you and it will deflect it.

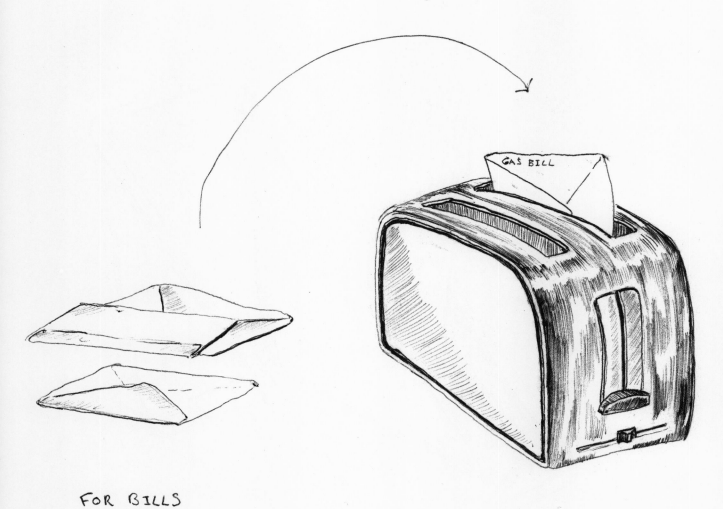

FOR BILLS

FOR BILLS
And other matter of burning importance.

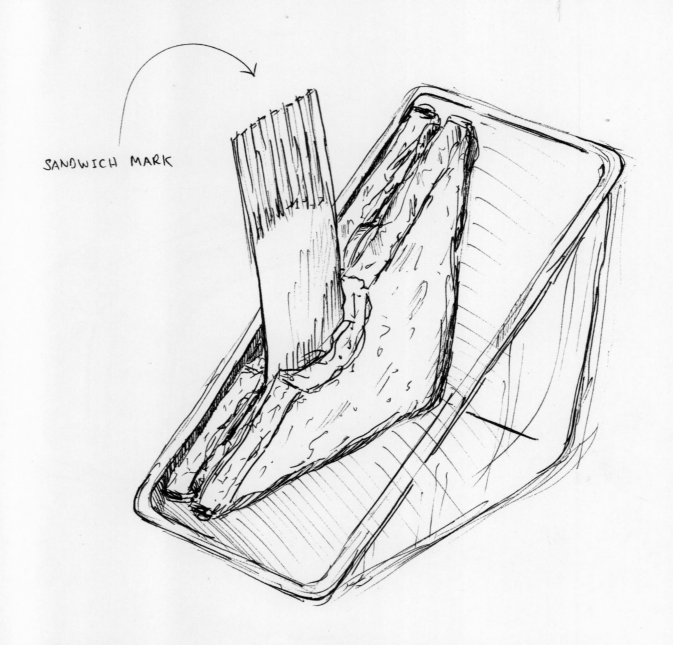

SANDWICH MARK

SANDWICH MARK
Used to mark your place in a sandwich, in order to pick up where you left off.

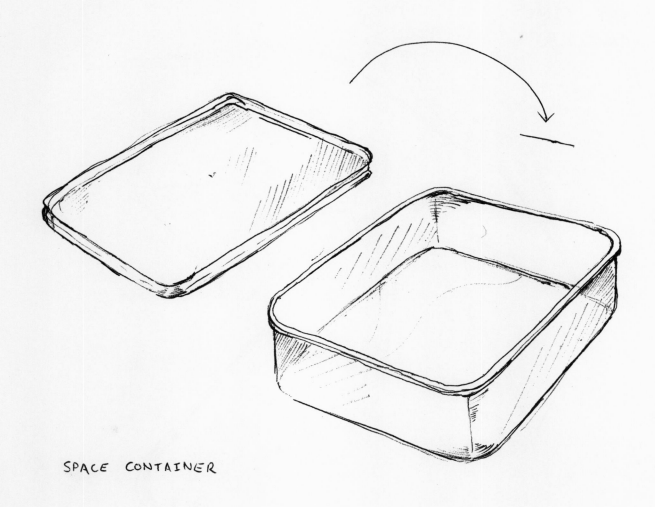

SPACE CONTAINER

SPACE CONTAINER
For transporting quantities of space.

NIGHT-TIME
UMBRELLA

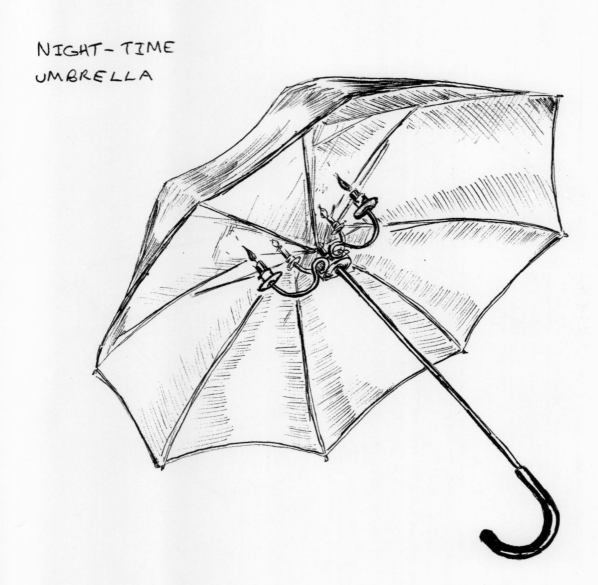

NIGHT-TIME UMBRELLA
The inventor of this device said he 'wanted to see the exact moment the rain stopped' when walking his dog in the rain late at night. The built in chandelier provided a steady glow for up to 3 hours, and it worked, but the dog wasn't impressed.

PENCIL TELEPORTER

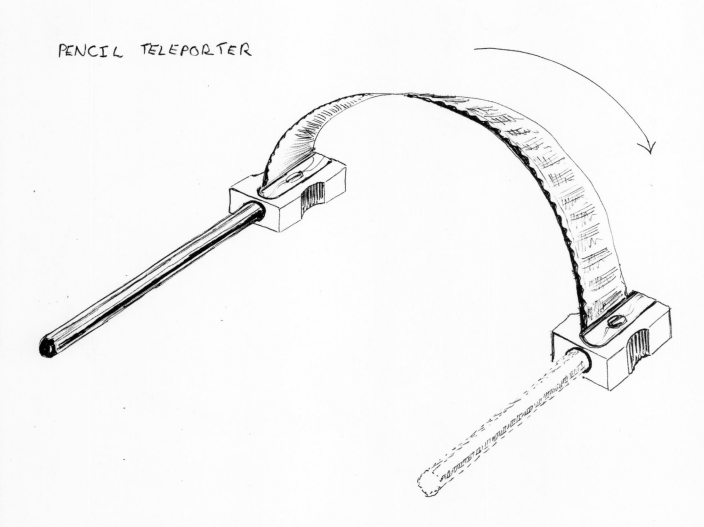

PENCIL TELEPORTER
For pencil teleportation.

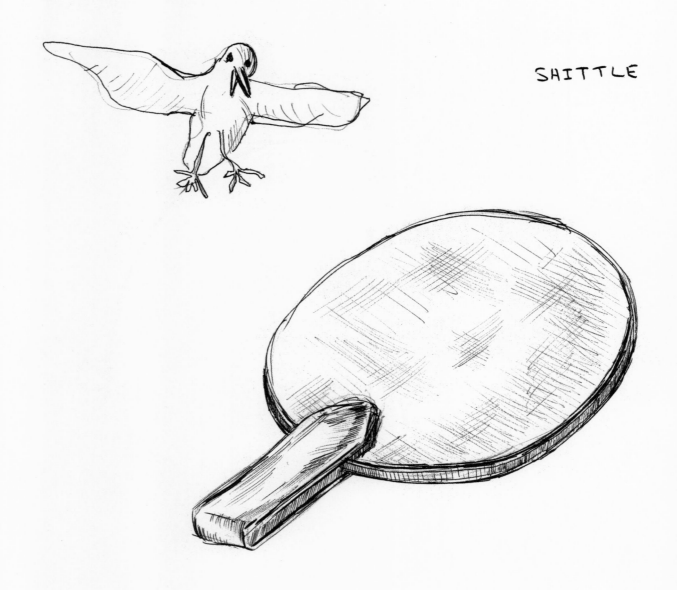

SHITTLE

SHITTLE
Waved frantically above the head, this will protect a person from incoming bird shit.

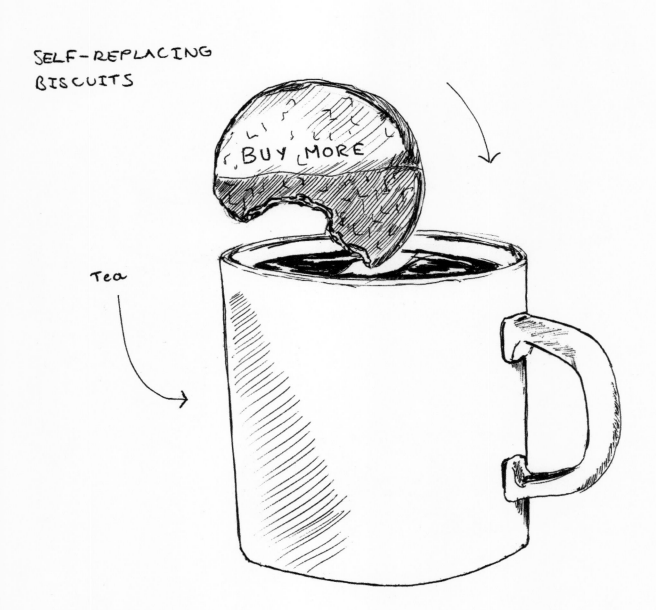

SELF-REPLACING
BISCUITS

BUY MORE

Tea

SELF-REPLACING BISCUITS
If it's a chocolate biscuit, 'buy more biscuits' will be clearly embossed.
If it's a digestive or rich tea the message will appear after dunking.

SHOE BOATS

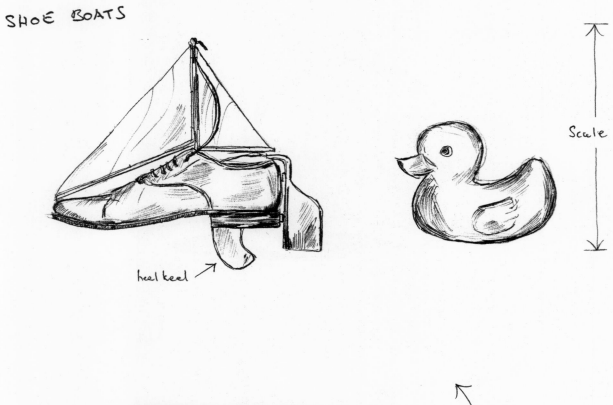

heel keel →

Scale

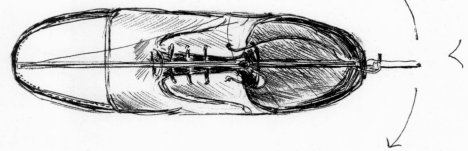

SHOE BOATS
When venturing into the great outdoors, crossing rivers and small streams is sometimes unavoidable.
Shoe boats were patented by a Mr C Moorsley after his shoe shop in Oxford flooded in the 1860's; the ingenious idea made
sure that all of his stock at that time could simply float to safety...however many stray pairs were picked up by a number of
locals, one being Charles Exford, who bought the patent and quickly put the shoes into mass production.

SPARE MINUTES

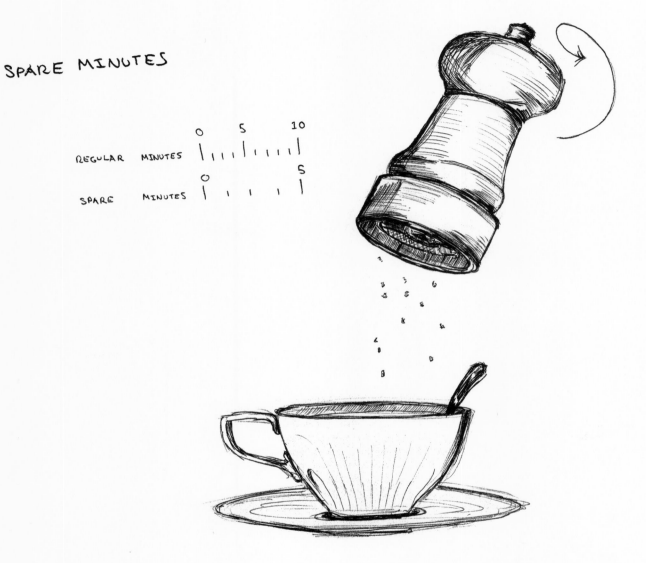

REGULAR MINUTES
0 5 10

SPARE MINUTES
0 5

SPARE MINUTES
Always good to have a few spare minutes.
Purchased in cafés and at railway stations, they come in a hand-held dispenser and are to be diluted in tea. The effect is instantaneous, taking one's time and stretching it to a leisurely length before a gradual fall back in sync with everyone else's. Overuse can lead to trouble however, with common side effects including last minute nausea and fashionably late diarrhoea.

VOCABULARY SUPPLEMENTS

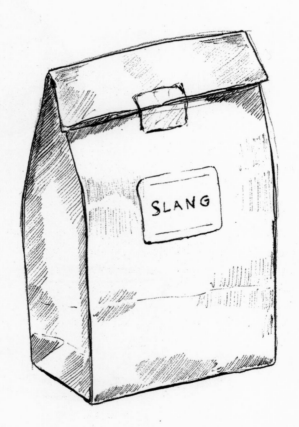

VOCABULARY SUPPLEMENTS

Example packages include: Reasoning & Argumentative, Slang, Professional Bullshit, Persuasive, Comedic and Estate Agent Compatible

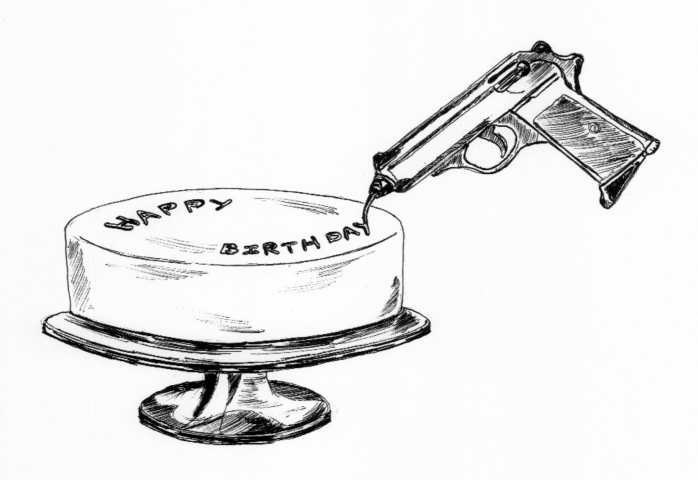

ICING
 — FOR MEN

BANANA SLICER

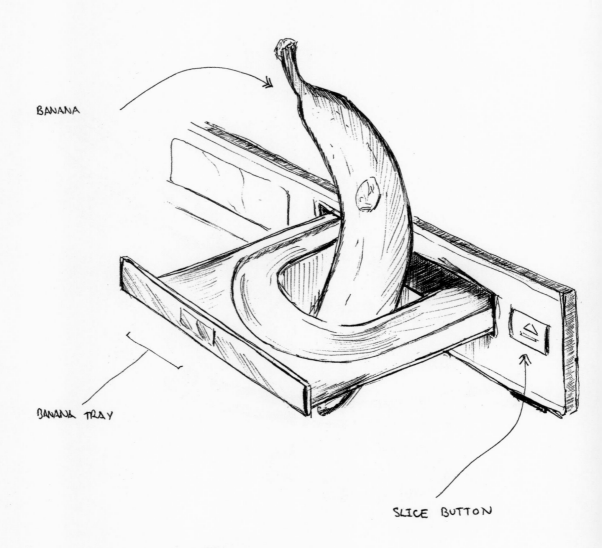

BANANA

BANANA TRAY

SLICE BUTTON

BANANA SLICER
For slicing bananas.

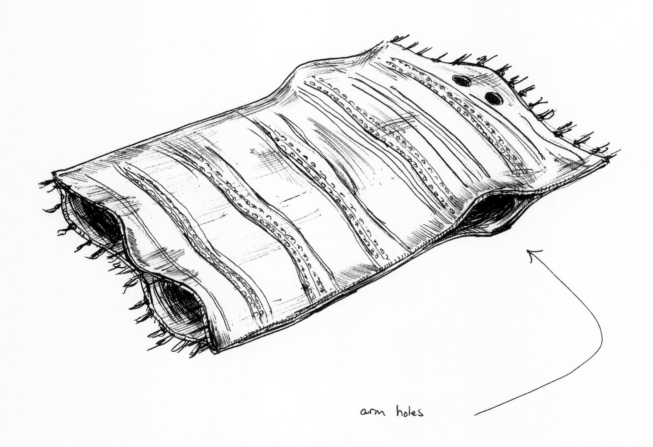

arm holes

CARPET SUIT
To blend in on the carpet.

CHOCOLATE JUNCTION

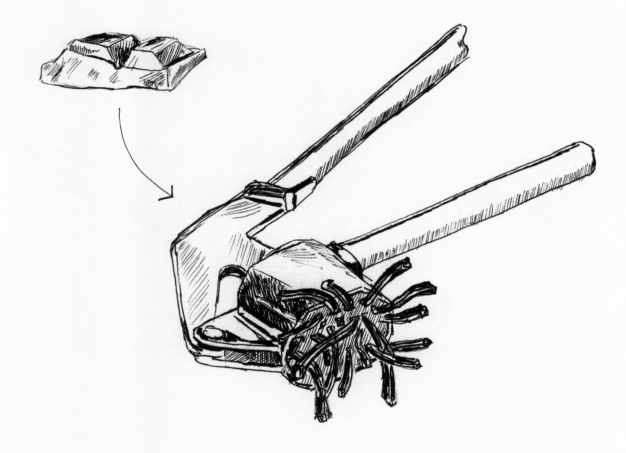

CHOCOLATE JUNCTION
For the rationing of chocolate when times were hard.

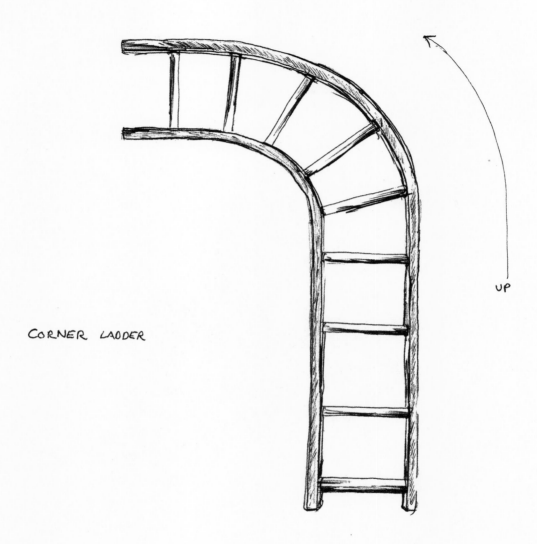

CORNER LADDER

UP

CORNER LADDER
For climbing corners.

DECISIONS

Decisions can be purchased easily should you want to buy them. They work their way into your blood stream and assert themselves for you. At the time of purchase they are 100% certain, after that the certainty will start to depreciate.

Caution does need to be exercised, as taking more than one decision at a time can result in:

-loss of direction / purpose

-flatulence

-a poorly tummy

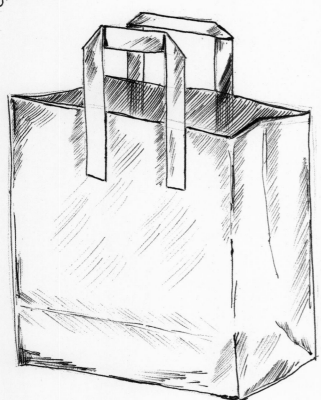

DISAPPEARING BAGS

DISAPPEARING BAGS

These bags disappear when turned inside out, but as the contents remain, plans for the disappearing nappy have been scrapped.

DOG CHARGER

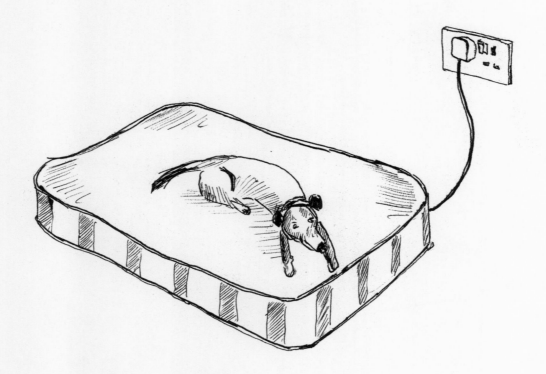

DOG CHARGER
For charging dogs.

DYSLEXIA DICTIONARY

DYSLEXIA DICTIONARY
Curiously, this is education at the end of it's tether.
The dictionary lists every word spelt incorrectly in the hope that the user will stumble upon the correct way of doing things themselves.

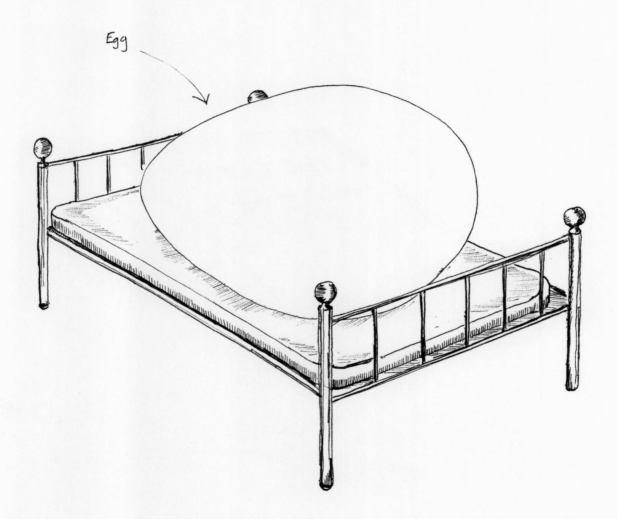

EGG BED

Egg

EGG BED
Thinking himself a bit of a laugh, a man called Alexander Eggle created a bed which allowed you to hatch out of an egg every morning. The beds were a roaring success until they started to go off, resulting in a bad smell and a lot of paperwork.

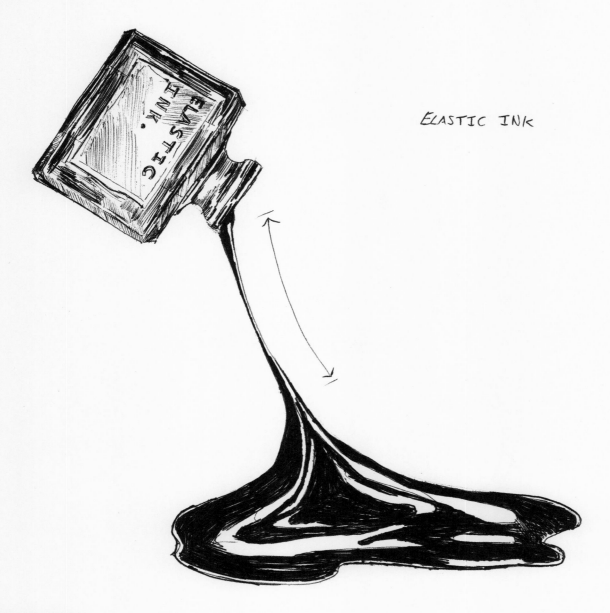

ELASTIC INK

ELASTIC INK

When applied, elastic ink bonds with the existing printed ink and permits expansion of the writing whilst maintaining it's form. Commonly noted for use with tape measures in the tailoring trade - an old trick to flatter portly clients into purchasing more than one pair of trousers.

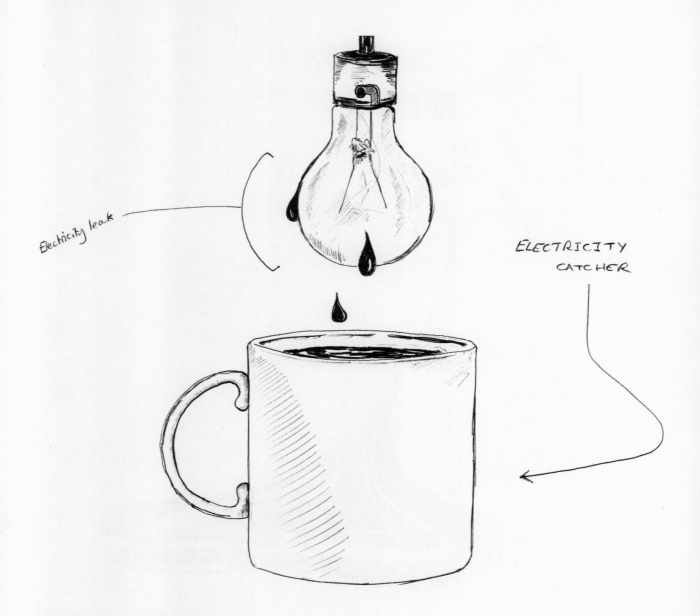

Electricity leak

ELECTRICITY CATCHER

ELECTRICITY CATCHER
Early electricity tended to be problematic, and the very first light bulbs would often leak.
This was due to a 'high cholesterol current' being too rich for it's insulator. It caused the wires to swell and eventually burst all over the shop, so the electricity catcher provided a short term solution.

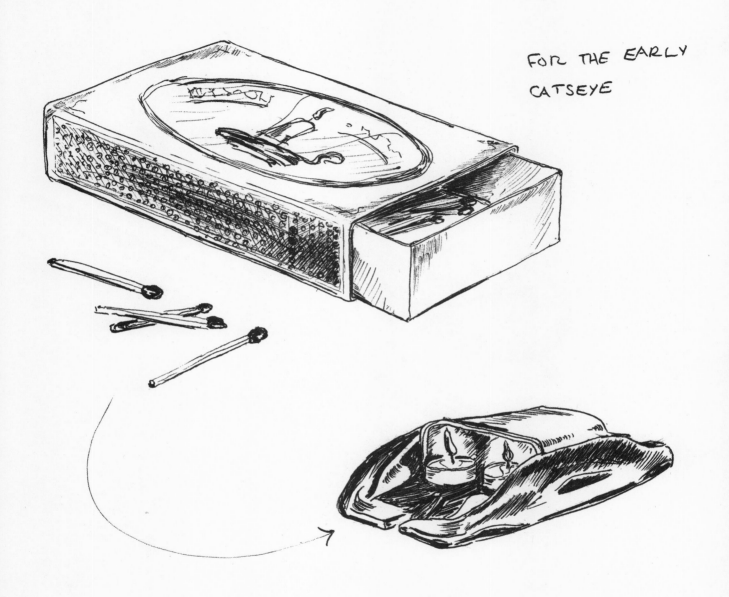

FOR THE EARLY
CATSEYE

FOR THE EARLY CATSEYE

Early catseyes were lit from underneath the road by a small man who's job it was to run ahead in a small tunnel. Our catseye man had his work cut out, as they were very temperamental and dependent on good weather.

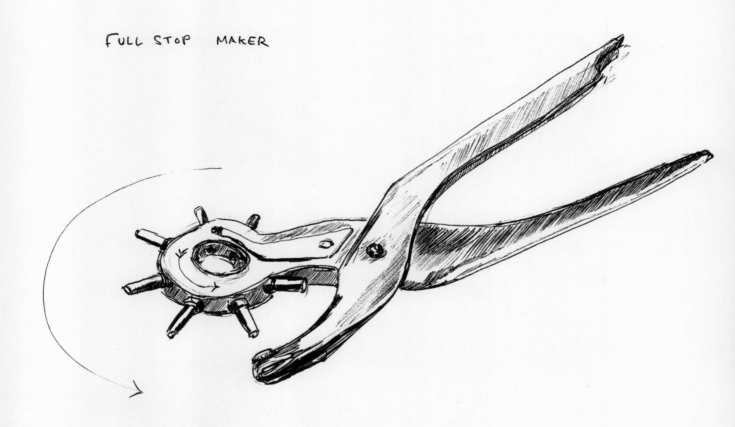

FULL STOP MAKER

FULL STOP MAKER

Not many people knew what the underside of a full stop looked like until the full stop maker was mass produced. Full stops are now capable of being used in both directions, and even stacked while not in use.

GRASS PAINTING MACHINE

GRASS PAINTING MACHINE
As far as we know, grass is only green when a person looks at it, so the grass painting machine was invented to ensure lawns retained their colour when backs were turned.
As well as painting grass, the machine belts out the most hideous noise.

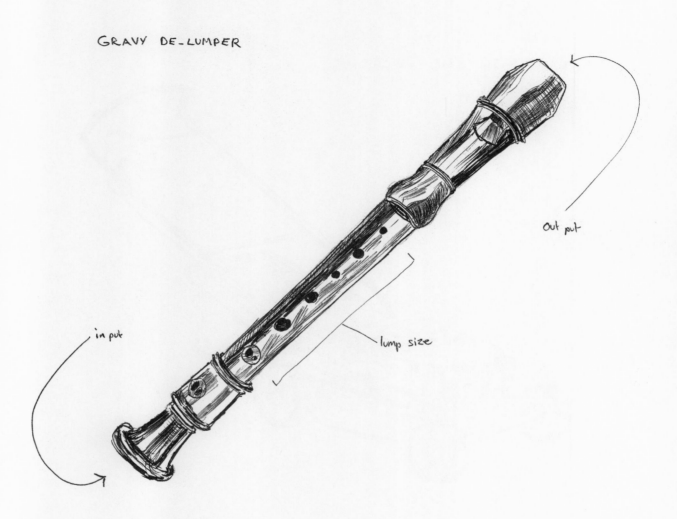

GRAVY DE-LUMPER

in put

lump size

Out put

GRAVY DE-LUMPER

Originating from France the 'd'lumpuer' was used to refine the flow of gravy after it was decided that nobody wanted to eat it with lumps. The de-lumper would accommodate for different sized lumps.
The only down side was that the thing made an awful noise.

HOOVER BAG

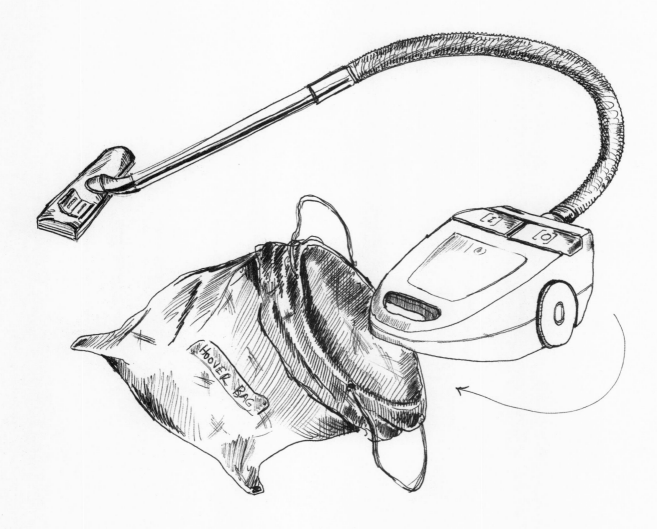

HOOVER BAG
For quiet hoovering.

Holes for feet

ICE BOOTS

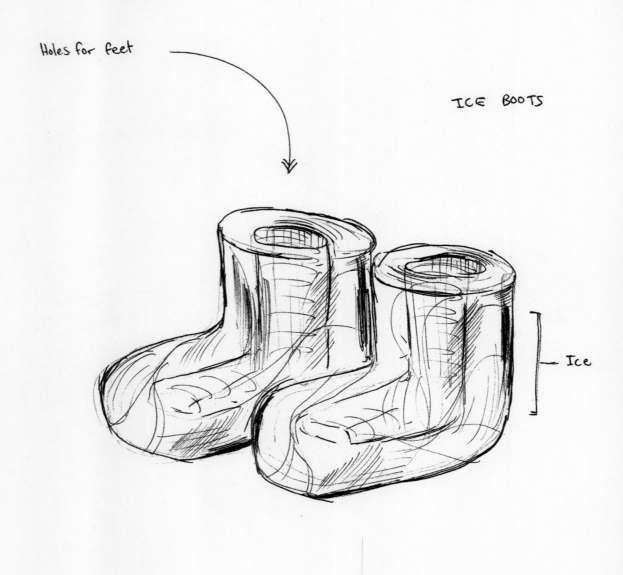

Ice

ICE BOOTS
Instead of skating on ice, why not use boots made of ice to skate on the road?
Perhaps harness a dog for a higher top speed.

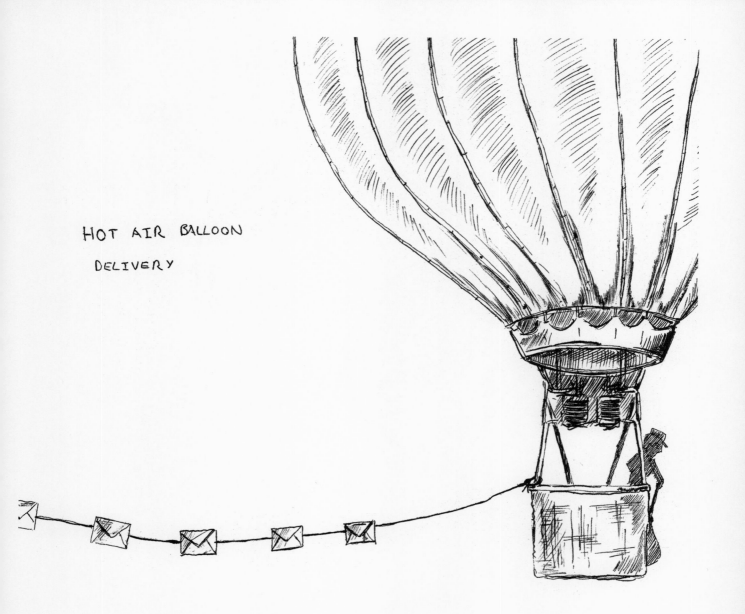

HOT AIR BALLOON

DELIVERY

HOT AIR BALLOON DELIVERY
Hot air balloons were always too large and awkward to be delivered by post, so it was decided that they would carry post instead...nicknamed 'Hot Air Mail' as the service promised more than it delivered.

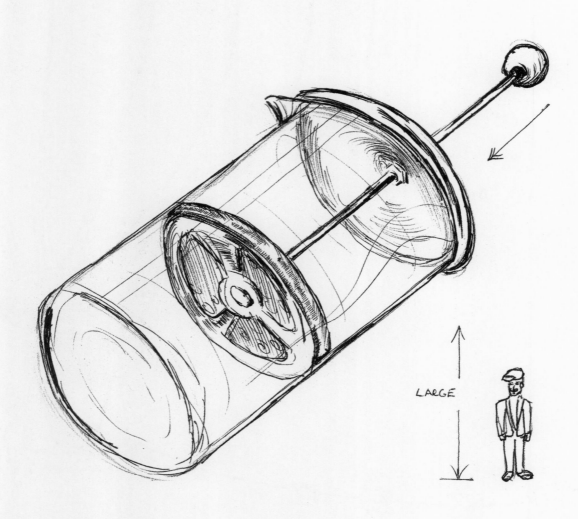

LARGE

LARGE COFFEE COLLIDER
For large coffee collisions.

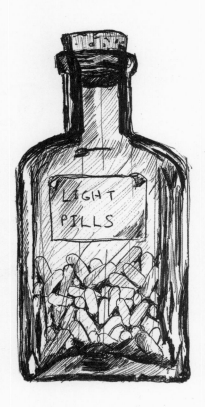

LIGHT PILLS

LIGHT PILLS
Long before the candle and modern light bulb existed there were light pills.
Consumed once a week, the light pill would allow a person to see for up to twelve hours a day. There was once a vast short-age of light pills. This is why we refer to 'The Dark Ages' and 'The Black Death'.

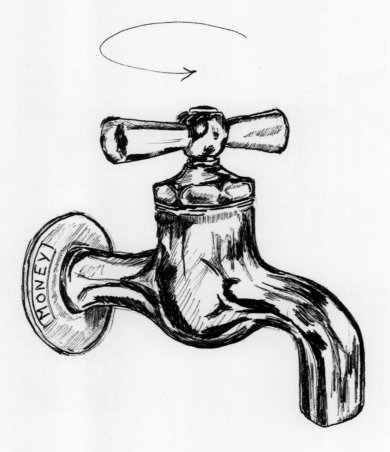

MONEY TAP
First set up by a resourceful alcoholic from Somerset, the money tap tapped into the local economy- and went straight down the drain via the local pub.

MOON SHOVEL
For obtaining moon samples.

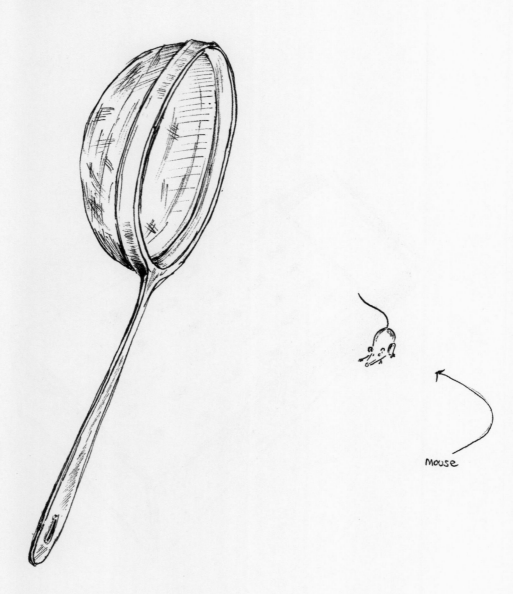

Mouse

MOUSE NET
Catch mice at an arm's length.

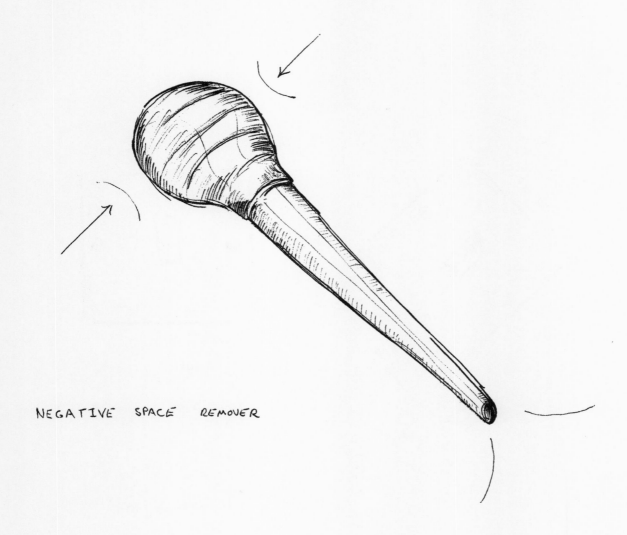

NEGATIVE SPACE REMOVER

NEGATIVE SPACE REMOVER
Negative space can be found everywhere: underneath animals and furniture, between the handles of coffee cups, behind televisions and almost anywhere else you can think of.
The negative space remover allows a chemical agent to be injected into the space, making it tangible for a few hours.
A splice can then be made, the space removed, and transported in a space container.

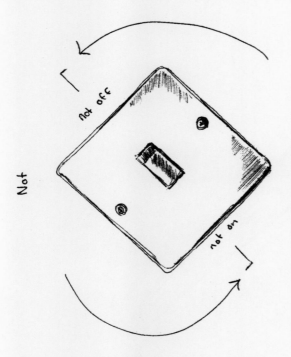

Not

not off

not on

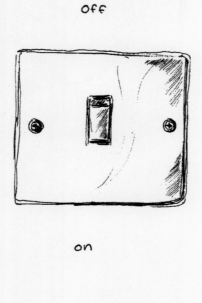

off

on

ON, OFF, & NOT

ON , OFF & NOT
Not is the alternative and lesser known choice to on and off.

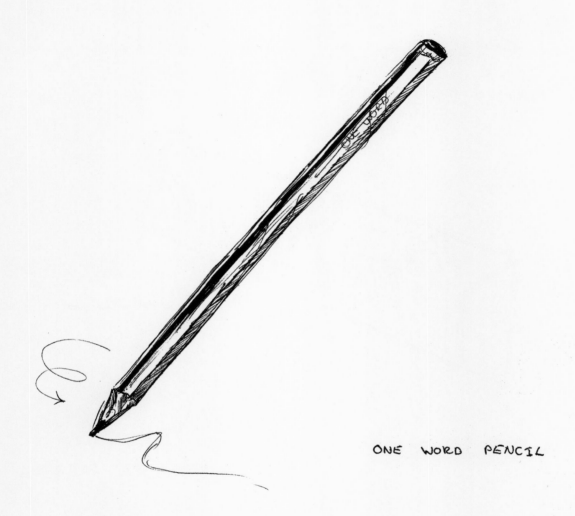

ONE WORD PENCIL

ONE WORD PENCIL
'Bollocks'

mounted to car

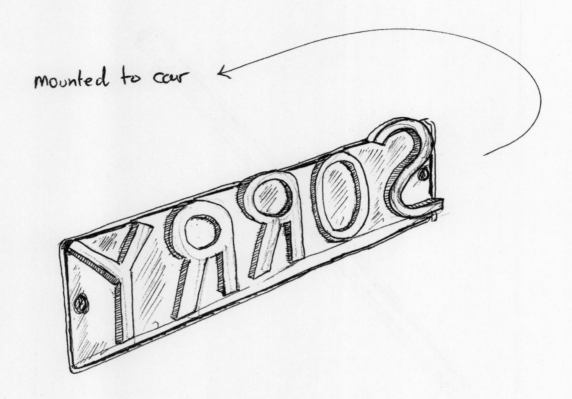

FOR PARALLEL PARKING

PARKING STAMP
For help with parallel parking.

PASTRY MEASURE

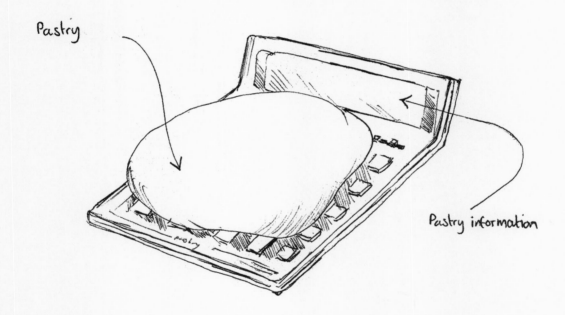

Pastry

Pastry information

PASTRY MEASURE
Pastry is placed onto measuring sensors, pastry information is displayed on screen.

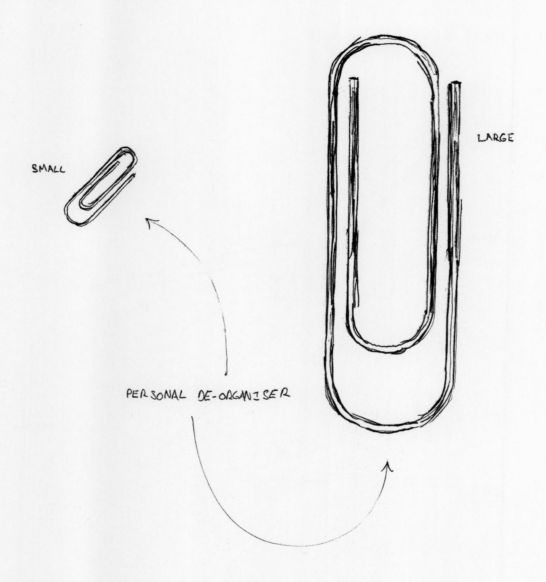

SMALL

LARGE

PERSONAL DE-ORGANISER

PERSONAL DE-ORGANISER
What's great about the de-organiser is that it allows a person to fasten an array of unrelated useful documents together, making them collectively useless.

Contributing to leaving what's needed where it's not wanted, the de-organiser gives scope to endless faffing, which can often prove useful when having little or nothing to do.

PREDATOR ENVELOPES

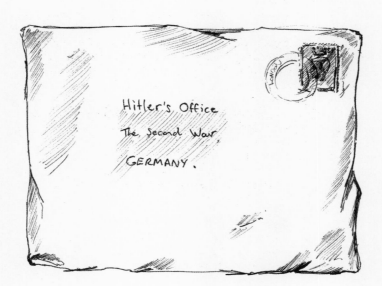

Hitler's Office
The Second War,
GERMANY.

PREDATOR ENVELOPES
This idea came about during the Second World War.
After being given written instructions the envelopes would be released into the postal system to intercept valuable information before posting themselves back to headquarters.
Unfortunately, the envelopes tended to be lazy, preferring to pick only on the slower, more vulnerable second class post.

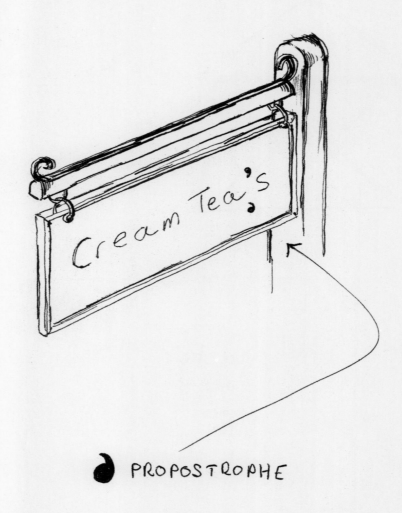

PROPOSTROPHE

PROPOSTSTROPHE
Added to any word with an unneeded apostrophe to cancel it out.

RAIN SCALES

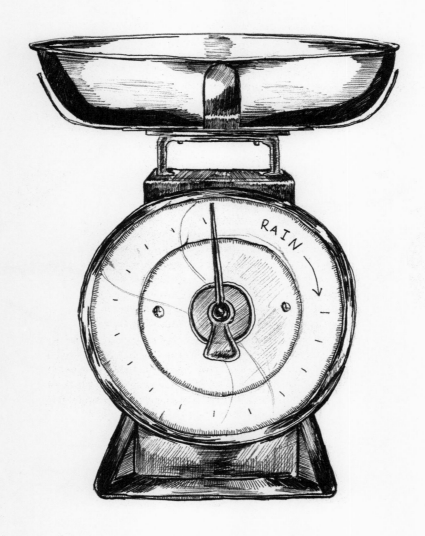

RAIN SCALES
Measures how heavy rainfall is for those interested.

SECOND CLASS ISLAND

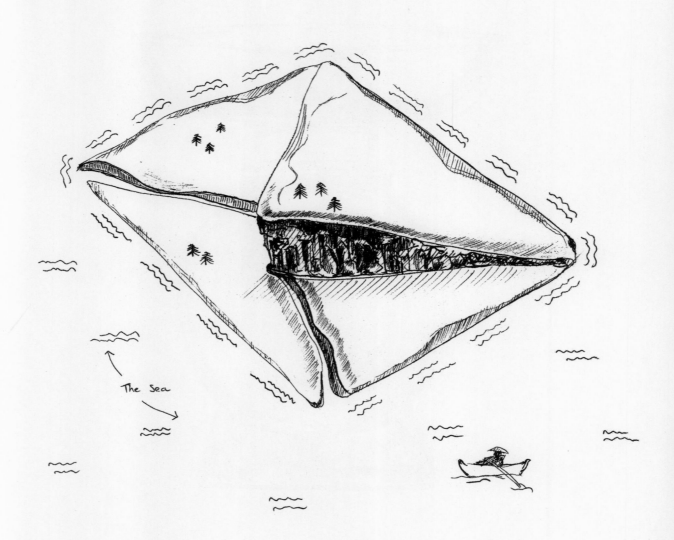

The Sea

SECOND CLASS ISLAND
Where post cards spend time before arriving back home.

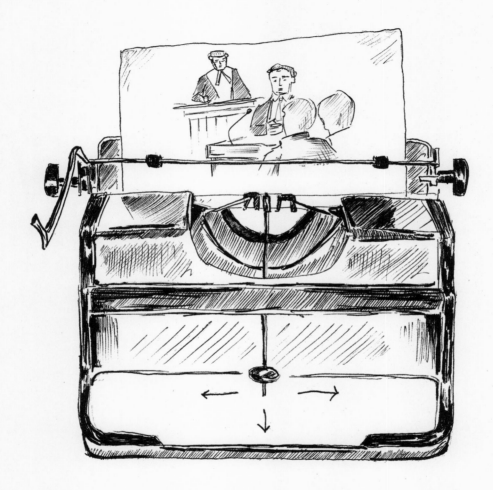

SIGHTWRITER
Surrealist and Cubist artists were a bit of a headache for court rooms requiring a dependable draftsman for legal proceedings. At the very least, drawings would appear upside down, feature people with two left eyes, or defendants with their ears listening in the wrong direction.
The sight writer was a machine that edited these mistakes out, giving the candid account needed, on the right size paper.

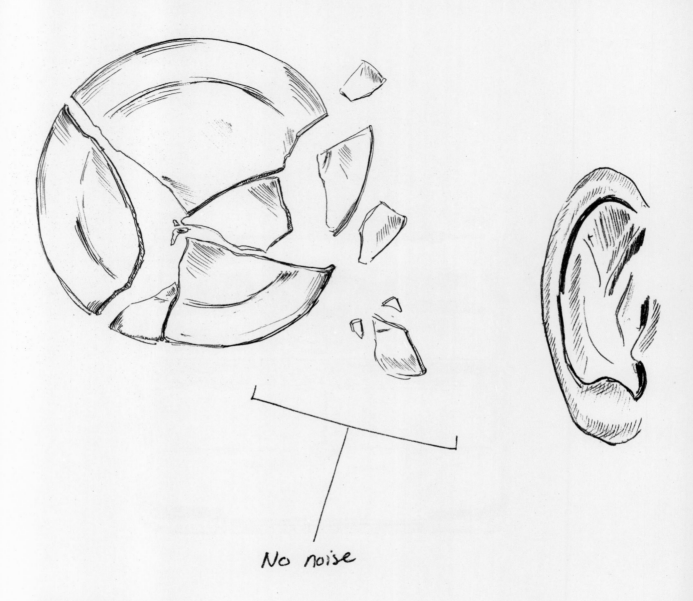

No noise

SILENT CROCKERY
The humble plate can produce up to 100 decibels when colliding with another.
To the everyday catering type this goes largely unnoticed, but can be enough to drive anyone else to drink.
In rather ill taste, the manufacturers of the 'seen and not heard' technology now available defend their high prices by claiming that they still need to put food on the table.

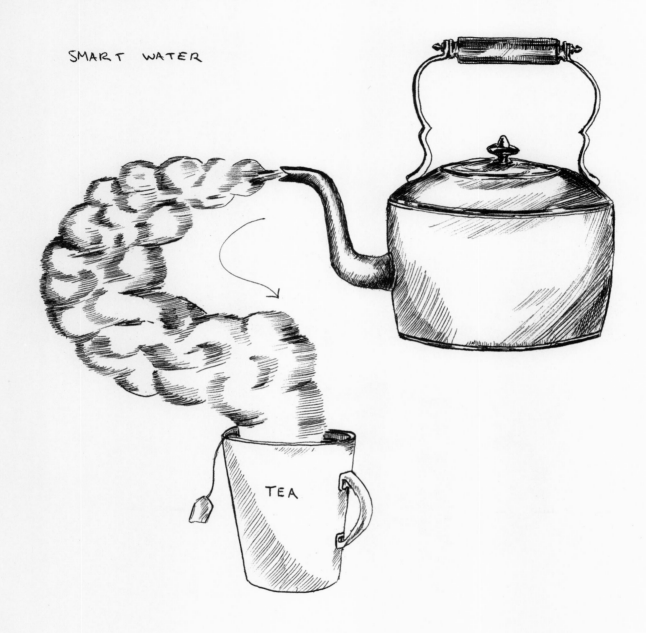

TEA

SMELL RECORDER

input

storage

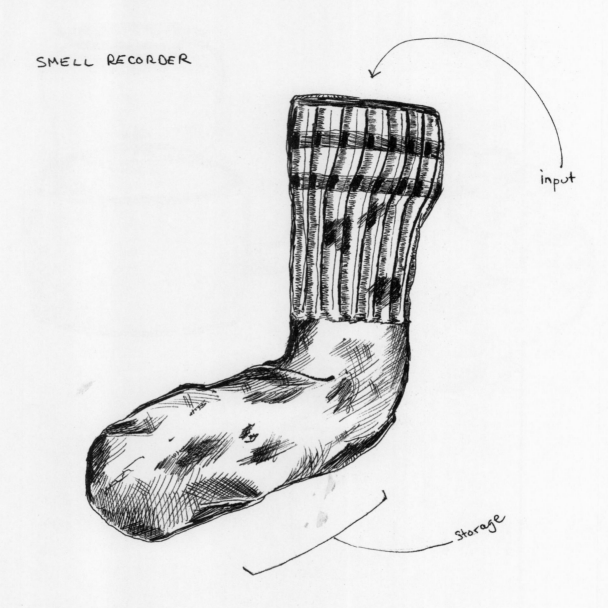

SMELL RECORDER
An unfortunate device developed for the recording of smells, sadly only capable of recording bad ones.

SPRAY ON PYJAMAS

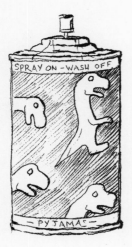
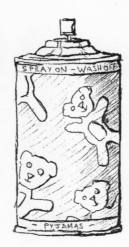

CHILDREN'S EDITIONS

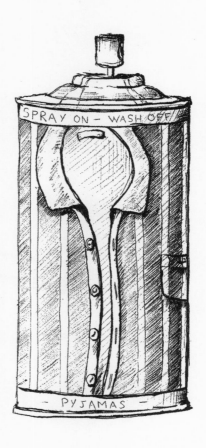

SPRAY-ON PYJAMAS

Like so many other inventions, 'Spray-on Pyjamas' were the brain child of an unusual circumstance. Whilst touring the amazon in 1905 explorer Basil Glyde discovered an excellent camping spot with a view to the river. Unfortunately a monkey made off with his pyjamas whilst he was putting up his tent. This caused the explorer considerable distress, prompting Glyde to make a record of the incident in his autobiography 'Up The River Without Pyjamas.' On his return, Glyde invented the spray-on-wash-off version we keep under our pillows today.

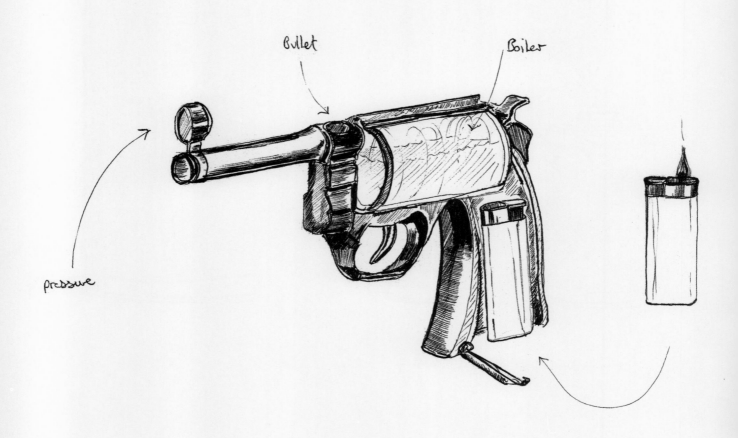

STEAM GUN

Bullet

Boiler

pressure

STEAM GUN
The steam gun was so unreliable that it allowed the user time to consider the consequences.
It also became unbearably hot.

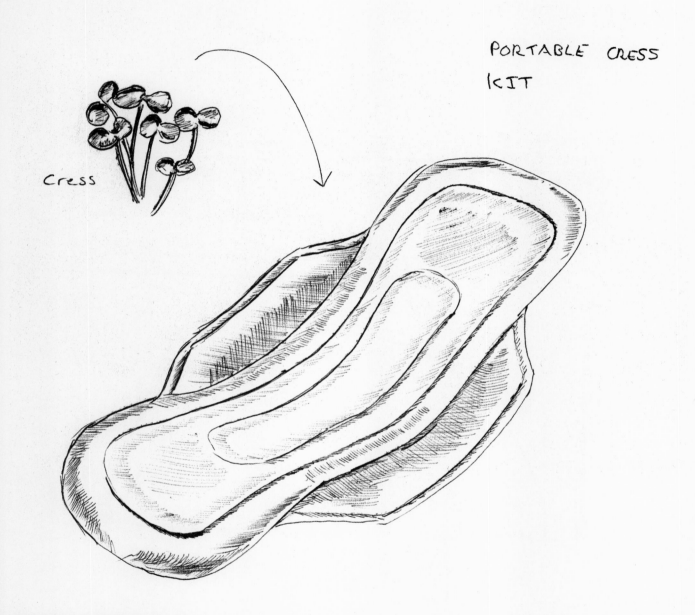

Cress

PORTABLE CRESS
KIT

PORTABLE CRESS KIT
For growing cress on the move.

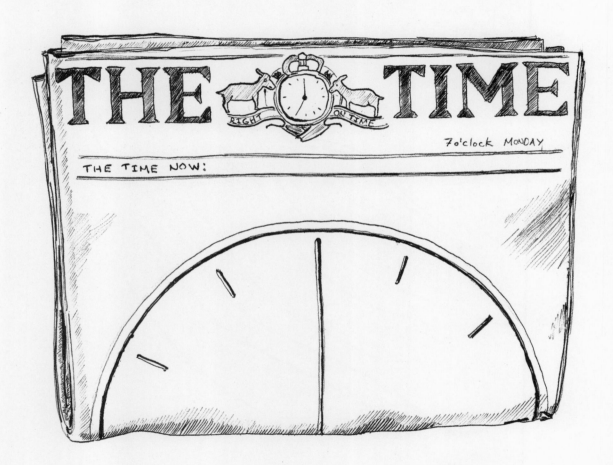

TIME BY POST

Before clocks were mass produced, time was privately owned by The Times newspaper, and so either told to you by someone else or delivered to you at the time enclosed.

Unfortunately people became tired of the dependency, 'ill timing' and irregularity.

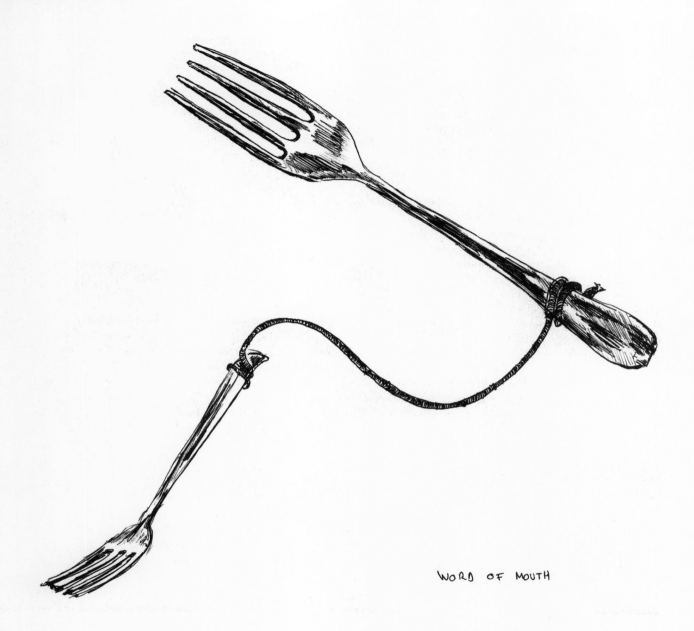

WORD OF MOUTH

WORD OF MOUTH
A connection allowing flavours to be shared / communicated

AIR SPLITTER

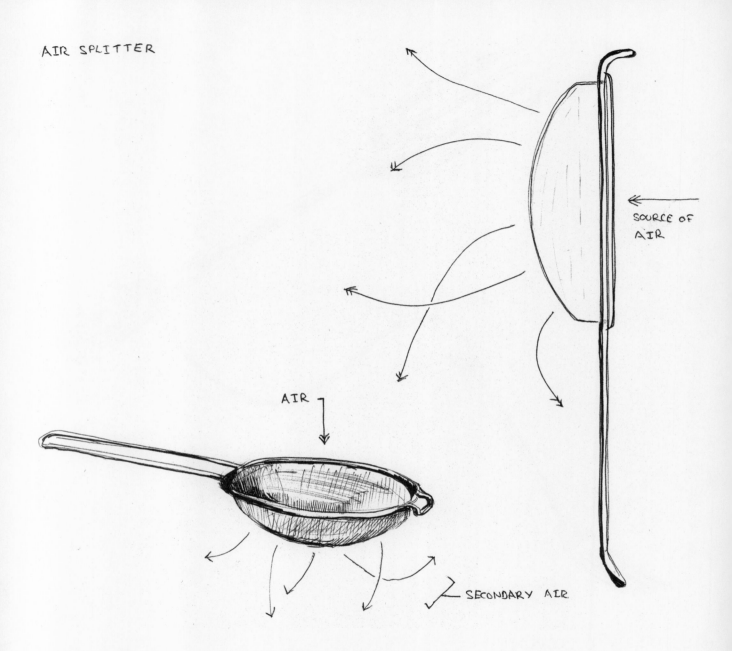

SOURCE OF AIR

AIR

SECONDARY AIR

AIR SPLITTER
Tool used to evenly distribute air amongst high altitude exploration parties.

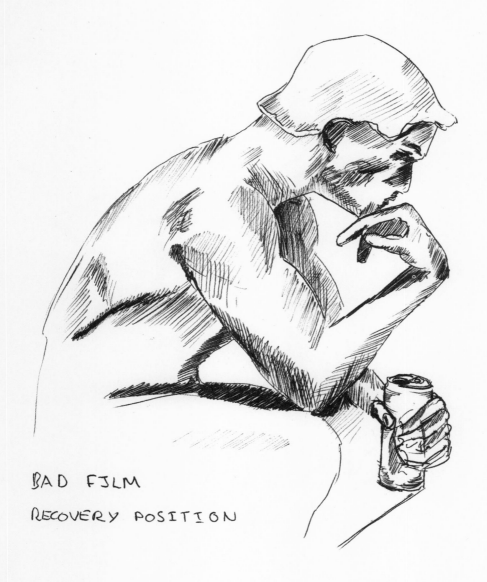

BAD FJLM

RECOVERY POSITION

BAD FILM RECOVERY POSITION
The only solution to easing the distress of seeing a bad film.
Adopt this technique for as long as needed in any room of any building after seeing a terrible film, repeat as necessary until recovered.

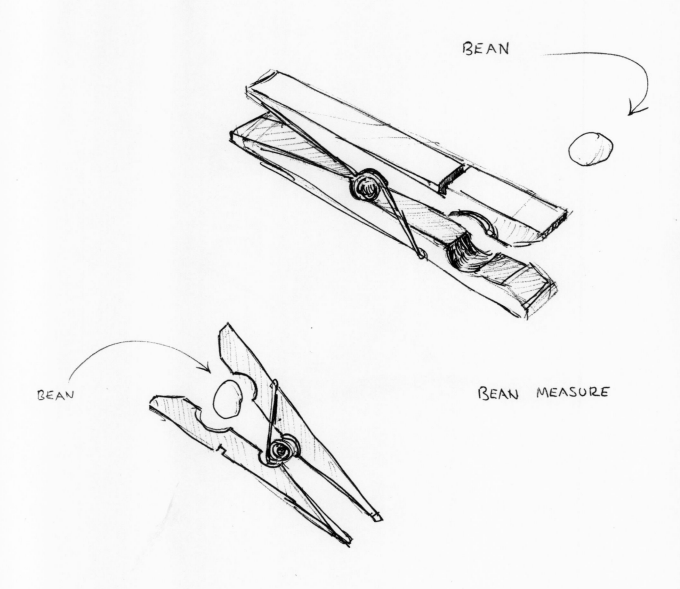

BEAN

BEAN MEASURE

BEAN

BEAN MEASURE
For measuring beans.

BREAD FLAP

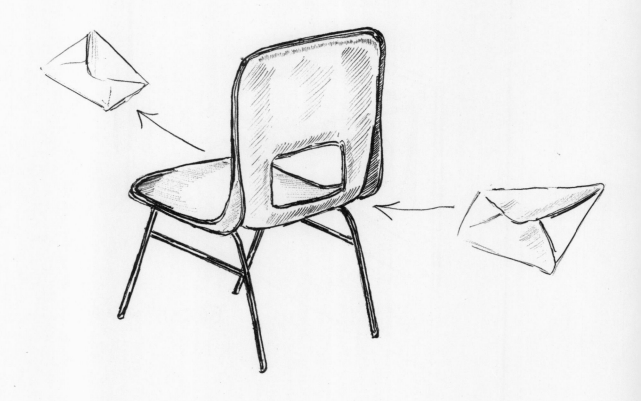

CHAIR POST

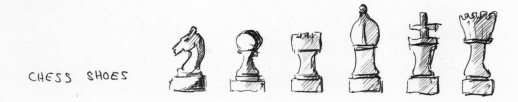

CHESS SHOES

CHESS SHOES
A pair of shoes that limit movement to that of chess pieces. The six varieties come in either black or white and give opportunity for enjoyable adventures. It is important not to wear an odd pair.

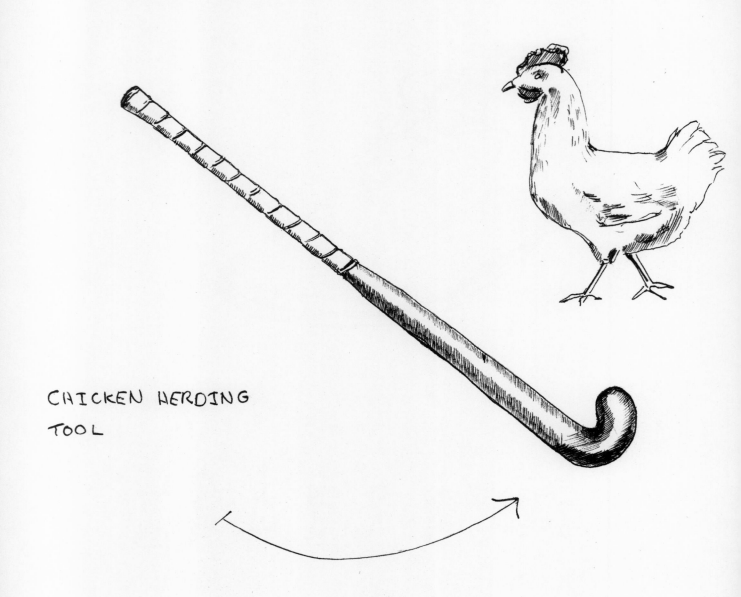

CHICKEN HERDING
TOOL

CHICKEN HERDING TOOL
For pointing chickens in the right direction.

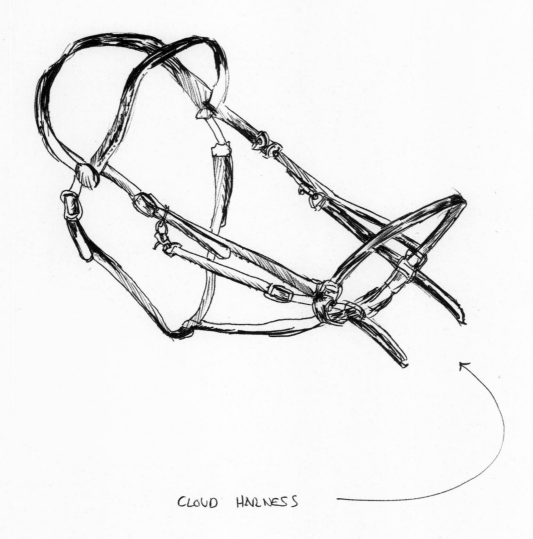

CLOUD HARNESS

CLOUD HARNESS

The first man to harness a cloud was thought to be completely mad as it turned out he had no idea what to do with it.
After tethering it in his garden for a few weeks, neighbours began to complain of bad weather and dampness among other things.
Thankfully our cloud catcher managed to squeeze the poor thing into a kettle and after bringing to the boil,
invited the neighbours round for tea.

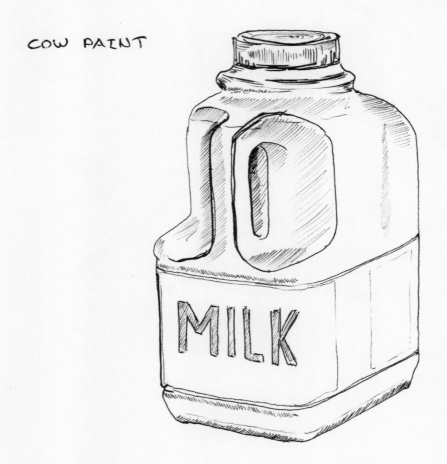

COW PAINT

COW PAINT
Cows were always meant to be white.
The reason they produce milk was so they could finish the job and paint over the other bits with their tails.
It's evolution's way of saying 'oops, here's what you need to tidy things up plus have a cappuccino on us'.

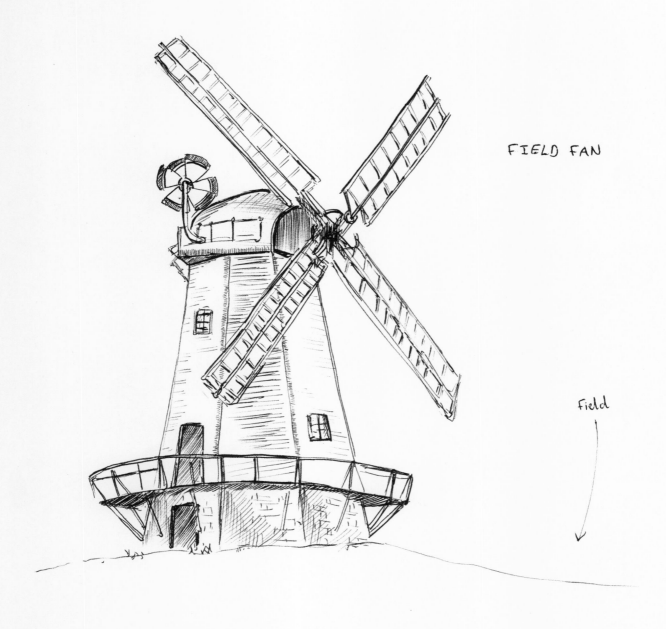

FIELD FAN

Field

FIELD FAN
These were built to keep fields cool during summer months.

GRAVITY CONVERTER

GRAVITY CONVERTER
Converts gravity into forward motion, this is how cars move along.

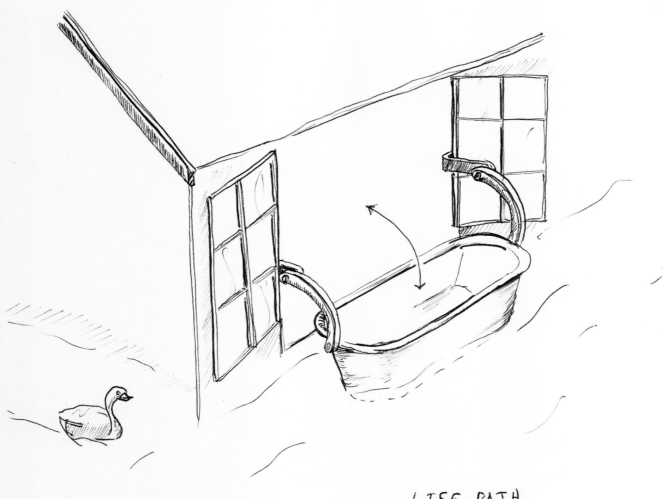

LIFE BATH

LIFE BATH
If a house floods, the life bath will disengage allowing a safe exit from the scene for up to two people.

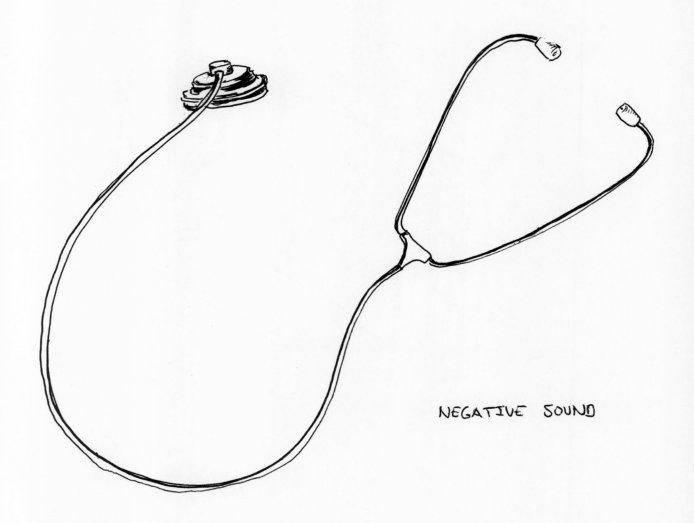

NEGATIVE SOUND

NEGATIVE SOUND

A man named Bryant discovered that when a sound wave cuts its pattern through a quantity of silence it leaves an imprint or 'cut-away' called negative sound. This Negative imprint lasts longer than positive sound and can be re-heard with the aid of the tool above.

Sadly this breakthrough didn't make Bryant a lot of money, so he went on to make a fortune selling the space beneath tables and chairs.

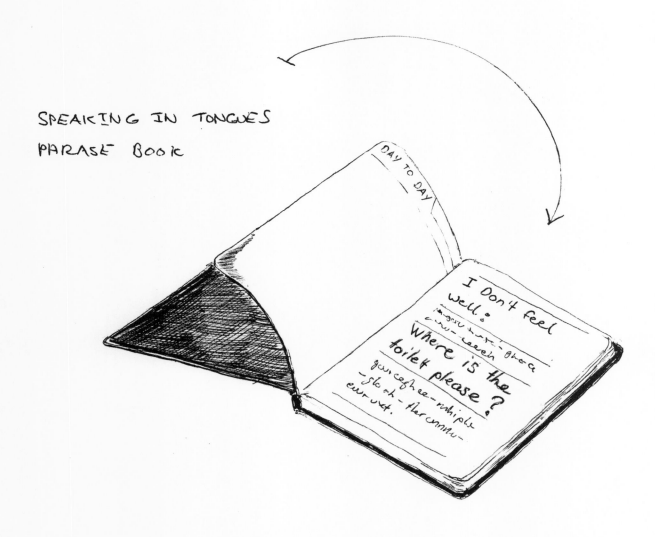

SPEAKING IN TONGUES PHRASE BOOK

Also known as the Glossolalia glossary, this book gives those who are interested in speaking in tongues half a chance of communicating with the tongue elite.

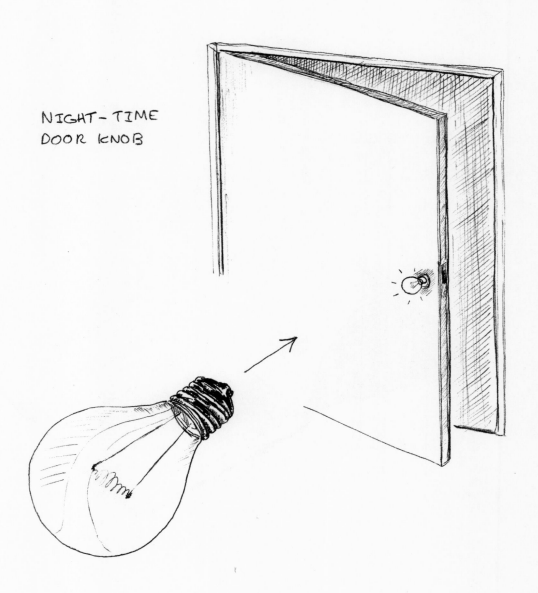

NIGHT-TIME
DOOR KNOB

NIGHT-TIME DOOR KNOB
Tried and tested, but sadly too hot to handle.

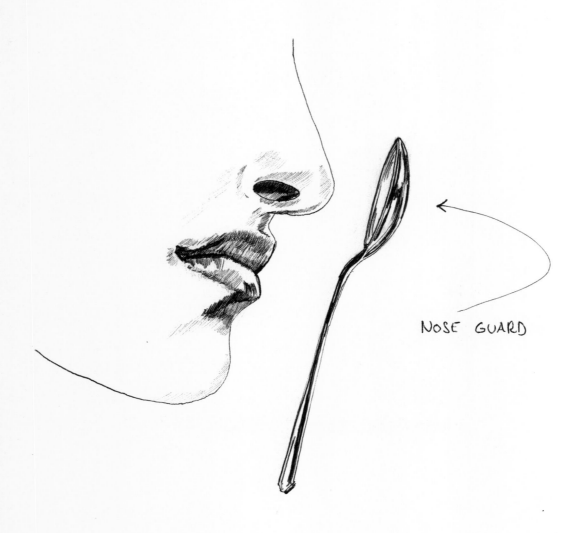

NOSE GUARD

NOSE GUARD
Romans used these during disputes at the table.

PRIMARY WORDS
Many dictionary fanatics remain convinced of the existence of four original words from which the rest of our words are descended.

Popular mapping suggestions include; 'jesus', 'bugger', 'pub' and more recently 'like'

RUSSIAN PENCIL TELEPORTER

During the 1960's Russian pencil engineers discovered that when used in a zero gravity environment a pencil teleporter displays some interesting characteristics.

SNOW - CROW

SNOW-CROW
Originally employed to warn off birds from Eskimo's vegetable patches.
Unfortunately they became addicted to carrots..

BUTTER GUTTER

BUTTER GUTTER
To give melting butter an even spread.

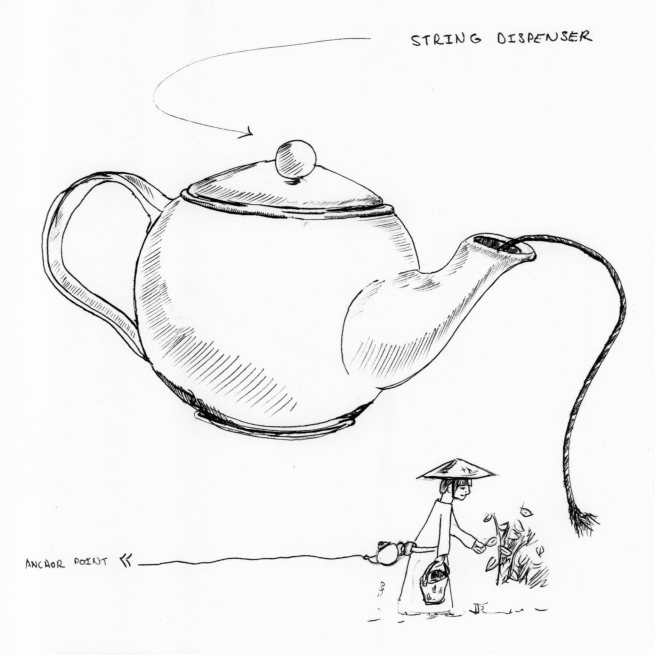

STRING DISPENSER
Strapped to the waist, this was used by workers on tea plantations in order for them to find their way back.

STRIPE-O-SCOPE

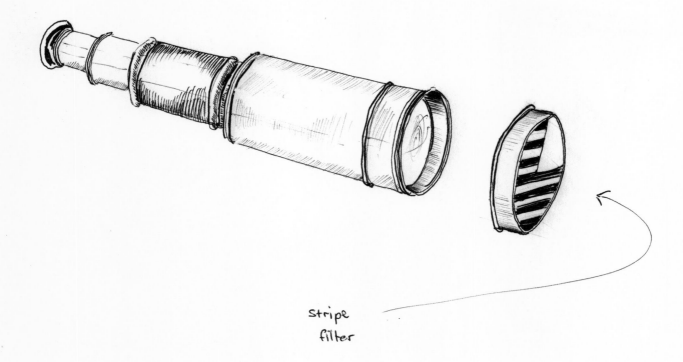

stripe
filter

STRIPE-OSCOPE
Christopher Columbus knew America was there, he just had a gut feeling.
After having a bit of trouble, he decided the key to discovering it was not where he was looking, but how he was looking.
The stripe filter allowed him to see both stars and stripes when pointed in the right direction.

'THROW YOUR FARTS'

THROW YOUR FARTS
Place the bad deed on somebody else.

BIRO ISLAND

BIRO ISLAND
Pens migrate here without permission. Someone needs to draw a line in the sand.

HUMILIATOR

HUMILIATOR
To power the lift music played in boring buildings.

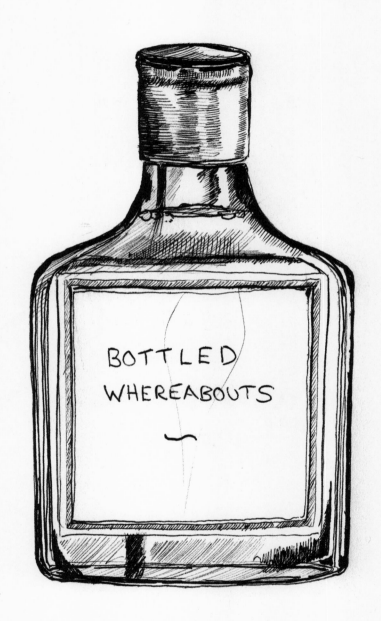

BOTTLED WHEREABOUTS

Drink this and you'll know where you are.

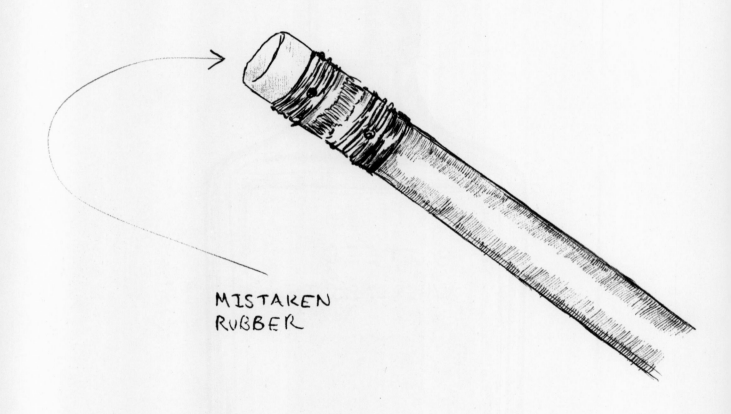

MISTAKEN
RUBBER

MISTAKEN RUBBER
The rubber was only meant to appear after the pencil's user had made a mistake.
Unfortunately, the first mistake occurred during its manufacture.

FOR SLEEPING
BAGS

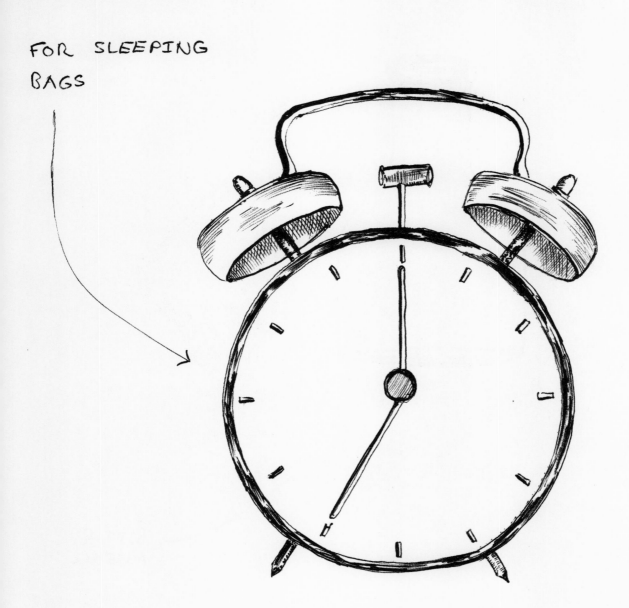

FOR SLEEPING BAGS

The man who invented the sleeping bag couldn't help feeling disappointed, as while it worked well, he could never wake it up in the morning.
Luckily someone else came up with this device a few years later.

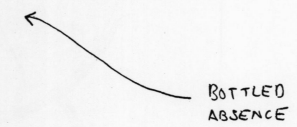

BOTTLED
ABSENCE

BOTTLED ABSENCE
Shrouded in mystery, incredibly unstable...and with only written records to rely on...bottled absence remains a bit of a WW1 historical headache.
With directions for use being 'drink, wait for a while, and disappear...'
Unconsumed bottles never went off, they simply disappeared, even the factory disappeared.

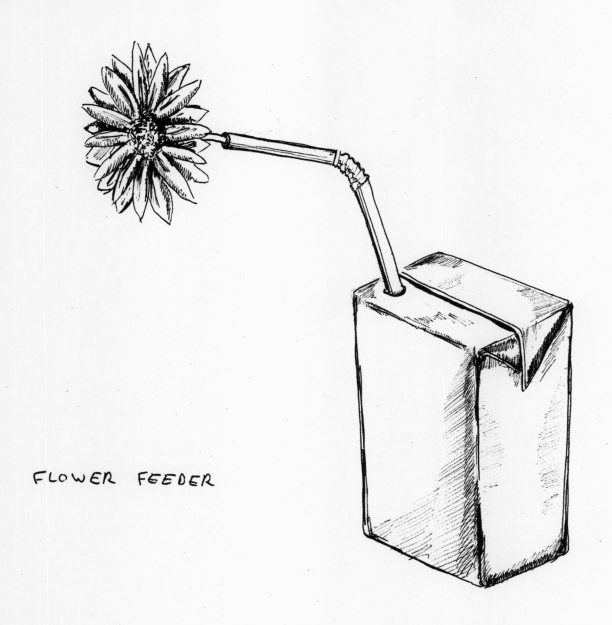

FLOWER FEEDER

FLOWER FEEDER
Pretty self-explanatory.

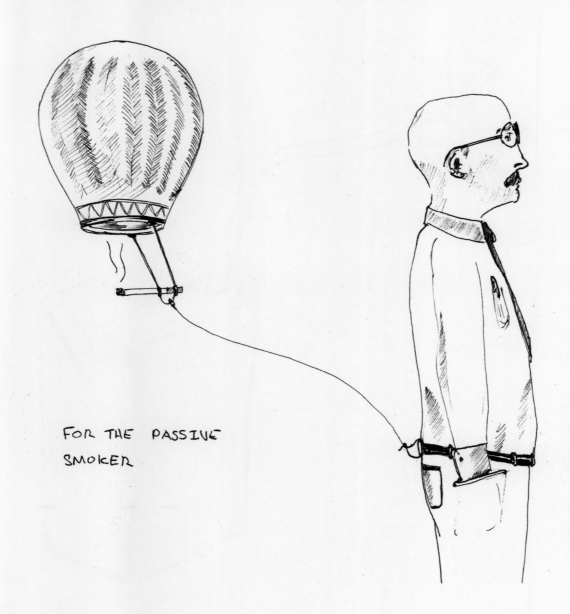

FOR THE PASSIVE
SMOKER

FOR THE PASSIVE SMOKER
Passive smoking can be avoided, but it can also be embraced.

FLY CATCHER

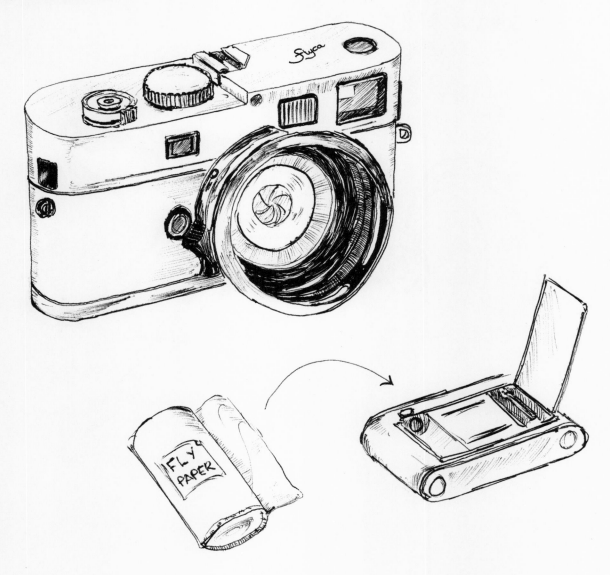

FLY CATCHER
Fly paper is loaded into the rear of the device on a roll, a shutter opens and closes very quickly and the fly is stuck in a moment.

BORING AID

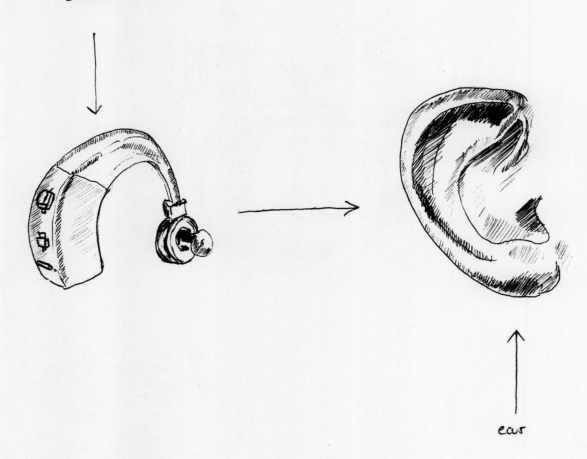

ear

BORING AID
Relays what you realise you weren't listening to in an instant.

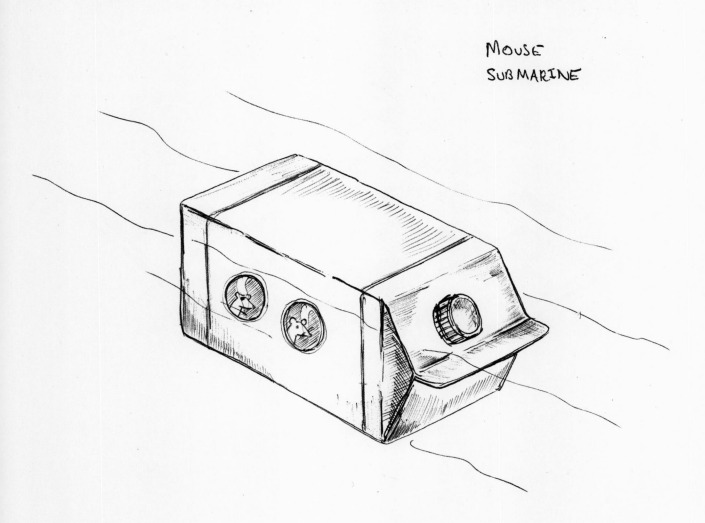

MOUSE
SUBMARINE

MOUSE SUBMARINE
For the enterprising mouse.

PENGUIN ORGANISER

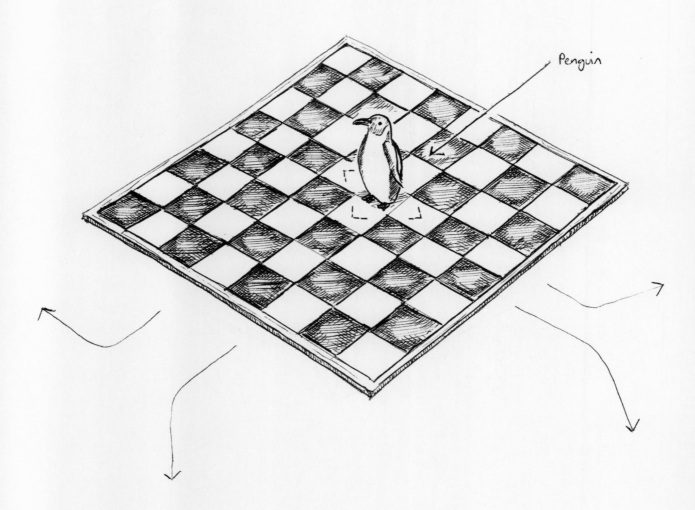

Penguin

PENGUIN ORGANISER
When penguins were first shipped abroad, it was difficult to keep track of how many there were. The penguin organiser solved everything.

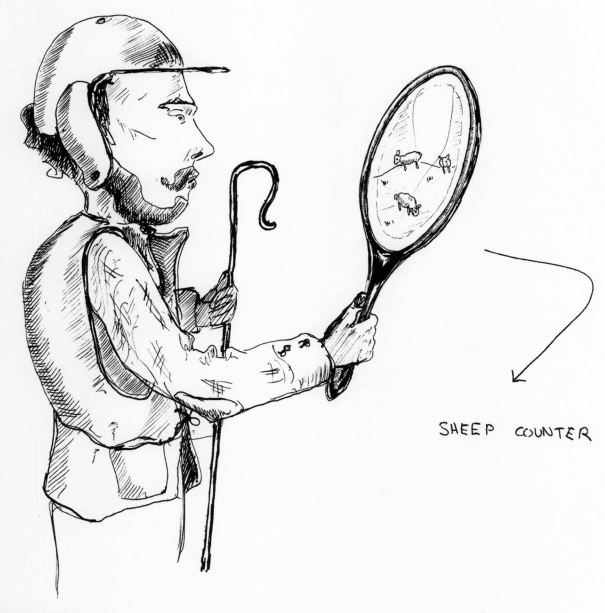

SHEEP COUNTER

SHEEP COUNTER
In the early days of shepherding, many shepherds would fall asleep whilst taking stock.
It was discovered that avoiding direct eye contact with sheep by counting them in a reflection solved the problem altogether.

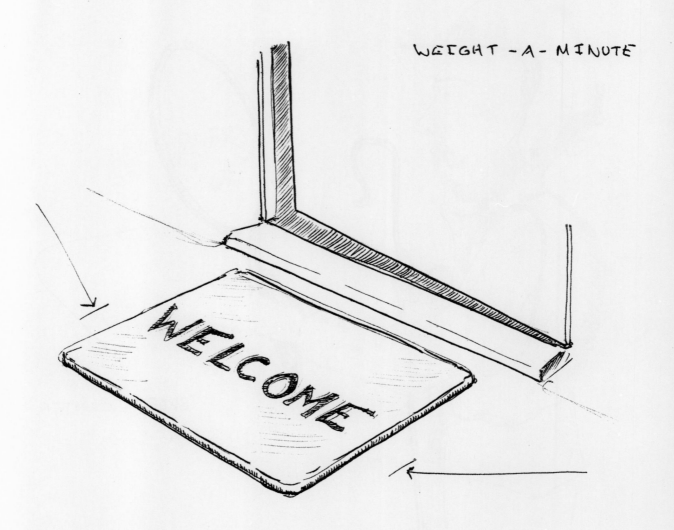

WEIGHT -A- MINUTE

WEIGHT-A-MINUTE
Found outside many homes, the weighing-in mat provides warning to residents of visitors likely to exhibit bull-in-a-china-shop behaviour.

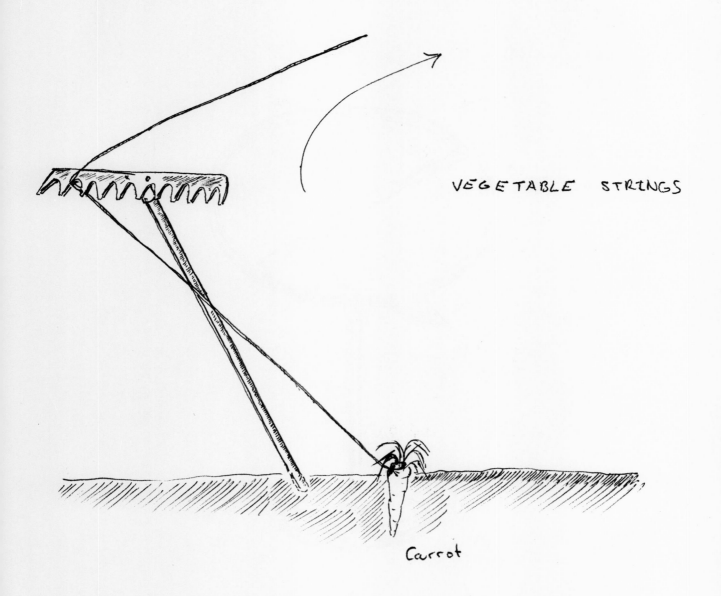

VEGETABLE STRINGS

Carrot

VEGETABLE STRINGS

Luckily for gardeners, most vegetables grow in the same direction. It's because of this that vegetable strings can be attached and tethered at an anchoring point or 'vegetable intersection'. The idea is that when they are fully grown the gardener can pull the corresponding string and the vegetables will place themselves in a neat pile ready to be used.

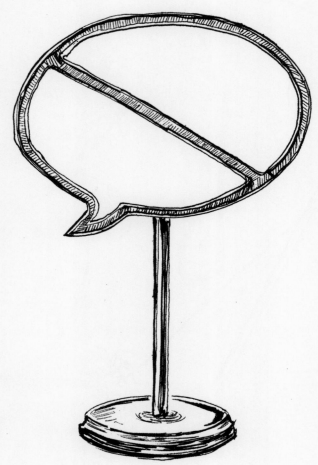

SPOKEN WORD
LIMIT

SPOKEN WORD LIMIT

This precaution was first put in place at an Edinburgh Library after the librarian's dog disturbed readers with a fit of verbal diarrhoea.

The 'unspoken rule' sees to it that any person (or indeed any dog) to enter within range will only be capable of speaking a certain number of words.

GRASS PAINT

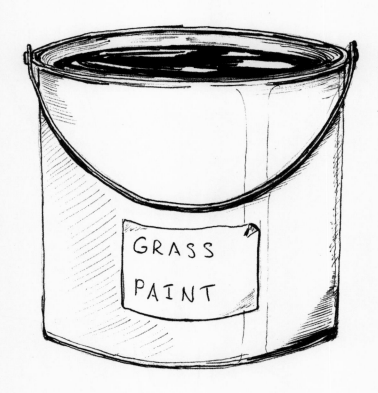

GRASS PAINT
Applied with a loud petrol driven machine, this paint makes sure the grass stays green just in case.

PROHIBITION
BALLOON

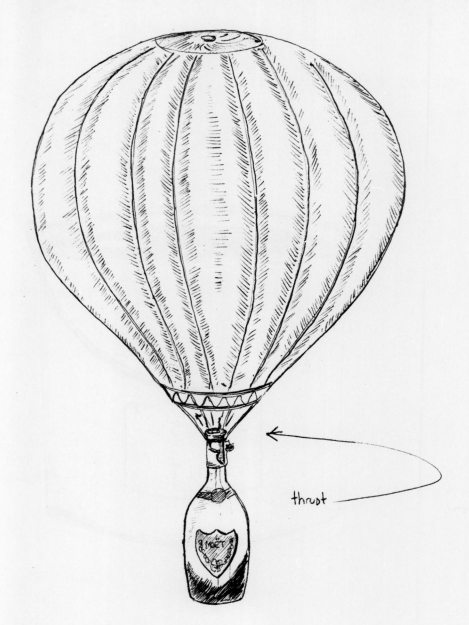

thrust

PROHIBITION BALLOON
People used these to transport champagne whilst celebrating the end of prohibition.
Once well shaken, each bottle would stay airborne for up to a minute which proved useful over long distances.

NOSE STOPPER

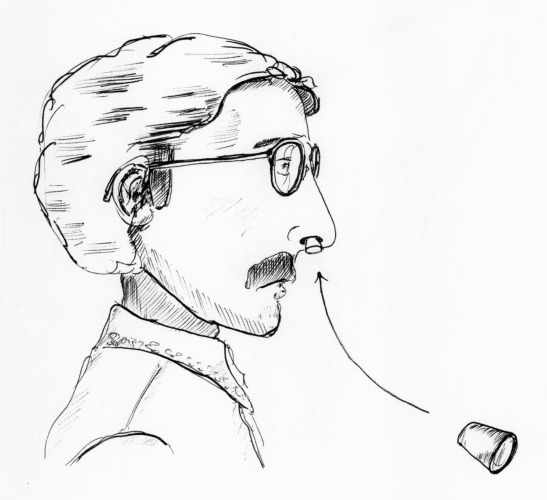

NOSE STOPPER
Block a nostril, breathe less, improve your carbon footprint.

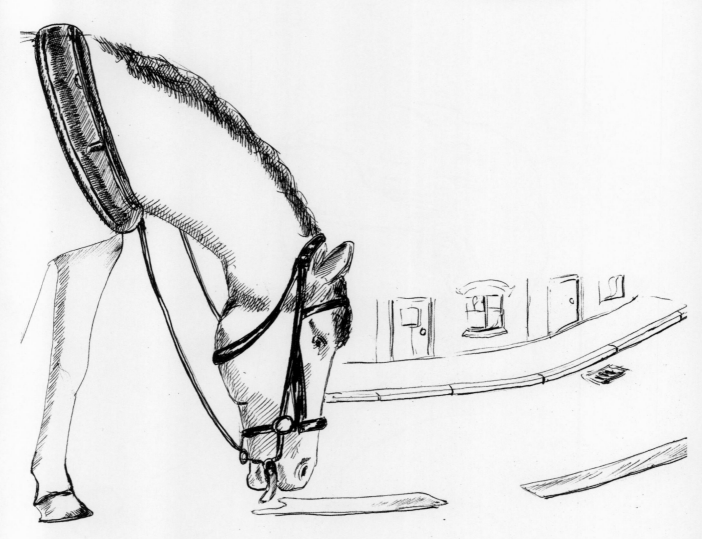

ROAD ICING

The first white lines were made from icing to encourage horses to go the right way.
It worked well for a short time, but neither horse nor coachman could stomach it.

COW WIND

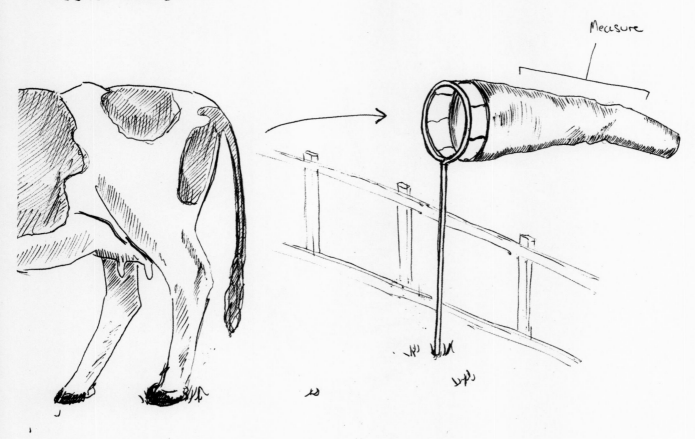

Measure

COW WIND
A cow's wind output can be measured by use of a cow wind measure.
If it flies at half mast, something has died.

DARKNESS MEASURE

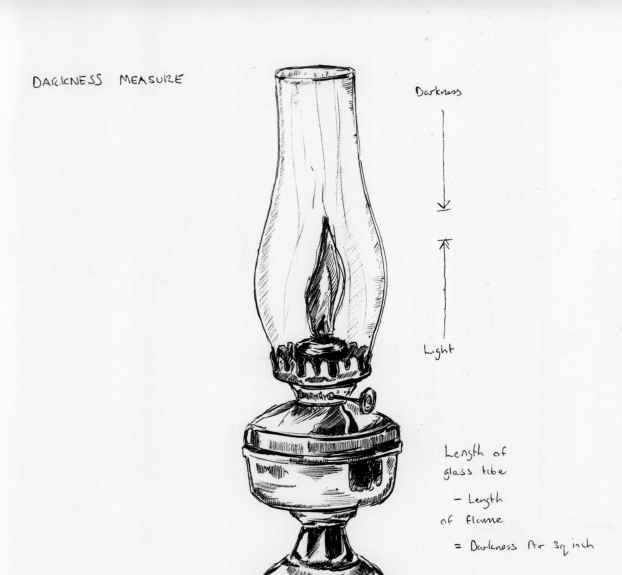

Darkness

Light

Length of
glass tube

– Length
of flame

= Darkness per sq inch

DARKNESS MEASURE
Tool used when measuring the pressure of darkness in pounds per square inch.

GERM SCARER

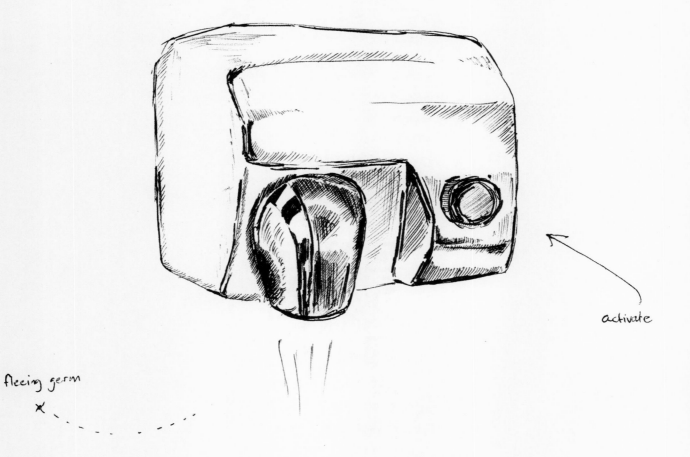

activate

fleeing germ
✗

GERM SCARER
Noise produced proportional to number of germs detected.

U N V E N T I O N S

THANKS TO EVERYONE WHO
BELIEVED / PUT UP WITH
UNVENTIONS FROM THE
BEGINNING IN PARTICULAR:
CHLOË, SEBASTIAN, TERRY,
JAMES, SAM, RACHEL, GARY
AND MY HAIRDRESSER FIONA

DON'T STOP AT THE BOOK!
VISIT www.unventions.co.uk
AND WITNESS THE WORLD'S
UNVENTIONS BEING
DISCOVERED FOR YOURSELF!